THE RISE AND RISE OF

BANKSY

MYTHS & LEGENDS

VOLUME 3

ANOTHER COLLECTION OF

THE UNBELIEVABLE

AND THE INCREDIBLE

BY MARC LEVERTON

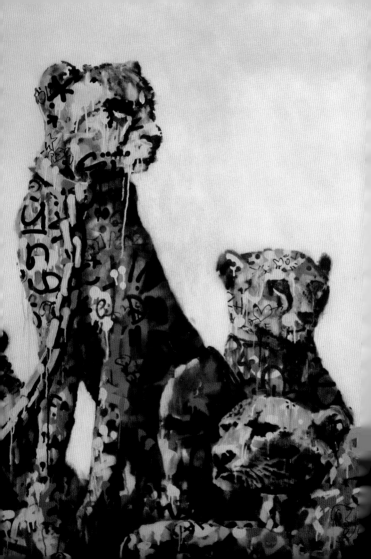

CONTENTS

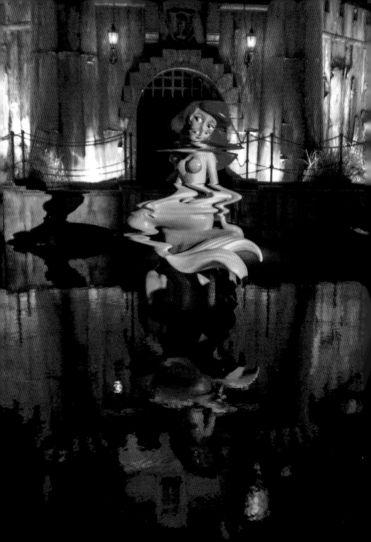

INTRODUCTION

The first edition of Banksy: Myths and Legends was published in 2011, at the time many people speculated that this was the peak of street art and maybe even the **peak of Bansky**. And by the time of the second edition of Banksy: Myths and Legends in 2014, this was perhaps proving to be the case. There were a couple of years of less visible work from someone renowned for being so prolific.

Let's try and get a wider perspective here. Back in 2000, Banksy put on his first exhibition in Bristol in the Severnshed. This is a local restaurant in the docks area of the city, and for a local artist this is a big deal. A couple of hundred people attended, and all the work sold out on the opening night. Anyone trying to make a living as an artist would be happy with this, making a couple of

grand in one night. Banksy has made a name for himself locally by stencilling extensively across Bristol. Rats, bombs, barcodes, trap doors, riot police...all of these and more had very much put his name on the radar of Bristol City Council and the local newspaper who want him to be accountable and to pay for the clean-up of all this vandalism. On the opening night of the Severnshed show, the police asked for a quiet word with Banksy. Apparently, he laughed off the request.

Fast forward ten years, and Banksy is releasing a Hollywood movie **Exit through the Gift Shop**. Celebrities are falling over themselves to own his work. His street pieces have appeared all over the world, and he is on his way to becoming a household name. At the same time Bristol is becoming a new capital of cool, in part due to the huge Banksy vs Bristol Museum show of 2009, but also due to all the other culture emanating from the city. Taking in music, festivals, TV and movies.

At the same time Bristol City Council become less concerned about the warrants they had previously issued against Banksy for anti-social behaviour. The local newspaper has also changed its tune, even printing souvenir posters of Banksy's work.

But this isn't just 'a rise to fame' story. To succeed within an existing framework of say the movie business or the art world is one thing. But to succeed in both, without playing by the rules of either...well, you have to respect that. Even if you think his art sucks.

It is a cliche to say that time gives us perspective, but after such a meteoric rise, by 2014 Banksy's work has been forced into a corner by people who saw his street work only as a commodity which could be taken and sold on. The sad sight of chopped up walls, and blue tarpaulins flapping in the breeze are becoming all too common place. The wow factor of standing in an unusual location admiring Banksy's latest middle fingered stencil salute was being replaced by a hole in a wall.

Let's also recall how the wider world was a very different place back in the mid noughties. The UK leaving the European Union was just a threat from grumpy old Conservative backbenchers. Donald Trump was a reality TV star and President Putin was just a harmless oddball.

This edition of Banksy: Myths and Legends chronicles Banksy's career between the years 2015 to 2023, and this period charts a renaissance. A further rise. The street work where Banksy made his name, is given less priority in favour of some bigger and more ambitious projects. These present new ways of seeing Banksy's work, some are designed to last a bit longer, some knowingly made to be fleeting. 'Catch it whilst you can' still the underlying vibe.

When Banksy releases some artwork, there is a huge reaction. Surprise, joy, unity, anger, plotting, subterfuge, theft. It is that ripple effect that this book tries to capture. The fans questions, the authorities haplessly trying to deal with the aftereffects, the locals joy at having 'their own Banksy'... or anger at an invasion of the great unwashed, whatever it may be. When the artwork has gone because you have been priced out, or it has been looted or put in a museum, all we are left with are the stories of what once was...the myths and the legends. Enjoy the ride.

(2015)

DISMALAND

No ducks given

Weston-super-Mare is the unlikely setting for an international art event, particularly the derelict Tropicana – an old-fashioned lido famous for its pool, beauty pageants and knobbly knee competitions. The council had long argued how best to use the site, but Banksy has an idea. Turn it into a theme park which celebrates misery. Add some twists on old classics like a grim reaper bumper car, bung in a shonky Ferris wheel and invite other artists (Darren Cullen, Paul Insect, David Shrigley) to contribute work. The rumour mill is soon in full overdrive and the first story is that Banksy is there amongst the crowd most nights fishing for lucky ducks, there is also speculation he is working as a car parking attendant.

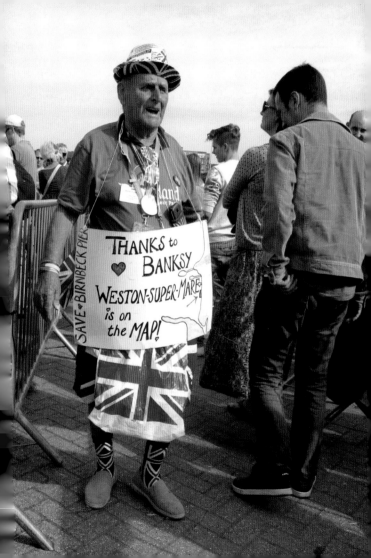

Club Tropicana drinks aren't free

Producing a major event like Dismaland costs money, but the public is only asked for a £3 donation. This is at the insistence of the council who don't want to see the kind of queuing chaos that the Banksy vs Bristol Museum show brought in 2009. How does Banksy fund the event? Is there Hollywood backing? Do local cider company Thatcher's contribute? Regardless, the event itself brings in £20 million to Weston's economy in the form of hotel bookings, restaurant bookings and knock-off Banksy fridge magnets.

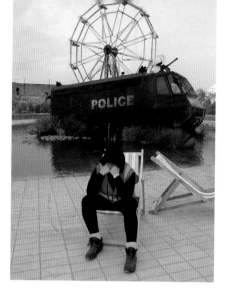

Online-super-Mare

The £3 tickets can only be bought online, but on the first day of the event the website crashes. An official statement suggests this is due to high demand, but Banksy fans online suggest this is a deliberate ploy from the artist to create a more dismal and depressing experience. Their proof being a static image on the website of a 'booking form' with booking time options, but no way of booking. Meanwhile, drama students from Bath Spa University are recruited as stewards and are trained in the art of the 'anti-customer experience'.

Employee of the month

The stewards take to their roles like ducks to water and none more so than Farhath Siddiqui, from Weston-super-Mare who becomes the face of the event. After the show has finished and Dismaland is nominated for an award in the South Bank Sky Arts Awards she is asked to go along to the event on Banksy's behalf. When asked what Banksy would make of it all, she replied 'I don't have a clue, I don't know him'. In the end Dismaland lost out to Lynette Yiadom-Boakye's Verses After Dusk.

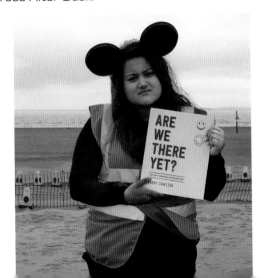

Face masks

Banksy is often ahead of the curve, and well before face masks became obligatory for the pandemic, guests were asked to wear masks on the closing night. Was this so that Banksy himself could attend? Massive Attack were due to play, but cancelled late, with Damon Albarn filling in and joining De La Soul on stage for an encore of Feel Good Inc. Other rumoured guests include Jack Black, Brad Pitt and Ant & Dec.

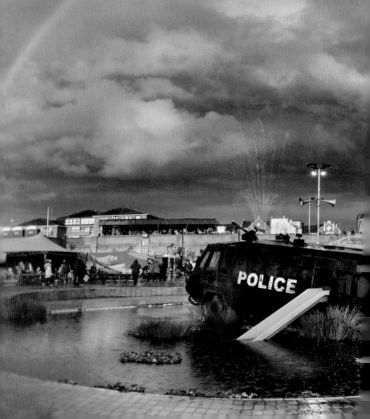

At the end of the rainbow

All the 52 staff who worked at the event over the summer were given a personalised print from Banksy with a hand drawn image of the riot van with a rainbow over the top. The personalisation is a nice touch, but also tells the world just who flogs theirs for £17k.

Officially forgotten

Local photographer Barry Cawston turns up to the opening event and attracts the attention of organisers with his documentary images. Barry remembers someone asking him to be the 'official photographer', although when he returns to the event – which he did a further 15 times - nobody seems to be able to verify this. He carries on regardless and creates a body of work which encapsulates the event and the wider pre-Brexit world of Weston, later publishing the results in Are We There Yet? including this image of a rainbow over Dismaland.

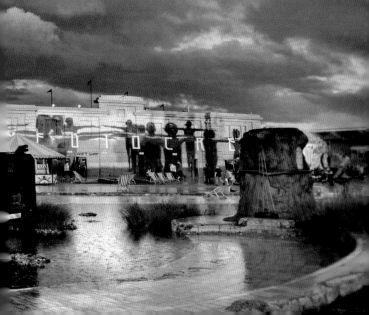

Dismal Aid

All the wood that was used in the creation of the fairy princess castle and in the rest of the site are taken to the Calais 'Jungle' for reuse and repurpose, mainly being used for shelters for stranded migrants. The wood is part of the aid donated by local people to help migrants that included food, tents and other essential items.

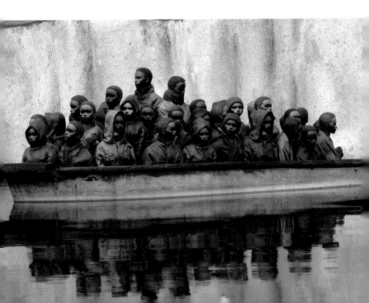

Come what may

A popular piece at Dismaland was the coin operated Refugee Boat, this was the first of a series of pieces on the migrant crises. The initial focus is on the situation at Calais where a camp of refugees trying to get into Britain had formed. Nicknamed 'The Jungle' by the press in Britain to make it appear more threatening and wilder than it actually was. The next piece is situated opposite the French Embassy in London and mimicked the Les Miserable stage show poster with a can of CS gas below and a QR code. Scanning the QR code took viewers to a video showing the migrant camp at Calais being raided by police using CS gas.

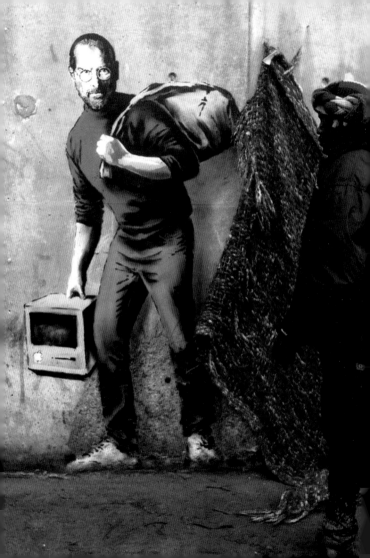

Welcome to the jungle

In Calais itself, Banksy's next piece shows Steve Jobs with a bag over his shoulder. Job's father was a Syrian refugee. Is the subtext are you keeping out the next Steve Jobs? There was an attempt to protect the work, which failed. Then a member of the camp 'protected' the remains, charging five euros to anyone wanting to see whatever was left of the vandalised piece. This migrant could be credited in foreseeing the NFT (non fungible token) craze that was to come five years later, proving Banksy's point that geniuses were indeed part of that camp.

Calais cover-up

The third piece in Banksy's Calais series depicts survivors on a makeshift raft after a shipwreck - a satirical take on the painting The Raft of the Medusa by Théodore Géricault. A piece described as a seminal work in French romanticism which has pride of place in the Louvre. The Banksy piece fared less well and was painted over by a Calais resident claiming his wall needed 'a spring clean'.

Back to school

The location of 'Burning Tyre' takes everyone by surprise one Monday morning, as it is inside a primary school in Bristol. Pupils had written to the artist, and he replied with the piece and a note which read:

'Dear Bridge Farm, thanks for your letter and naming a house after me. Please have a picture. If you don't like it, feel free to add stuff – I'm sure the teachers won't mind. Remember – it's always easier to get forgiveness than permission. With love, Banksy.'

It was lucky that the artist took the unusual steps of leaving a letter and signing the artwork as the school caretaker was gearing up to remove the piece which he initially thought was just your everyday kind of vandalism. Imagine explaining that one to the head.

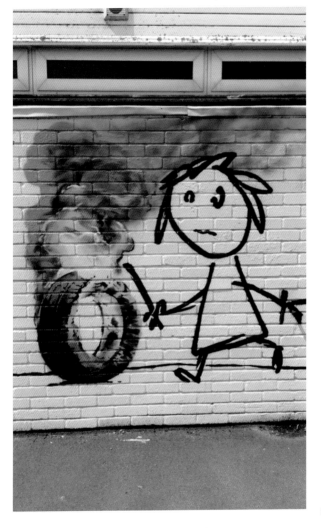

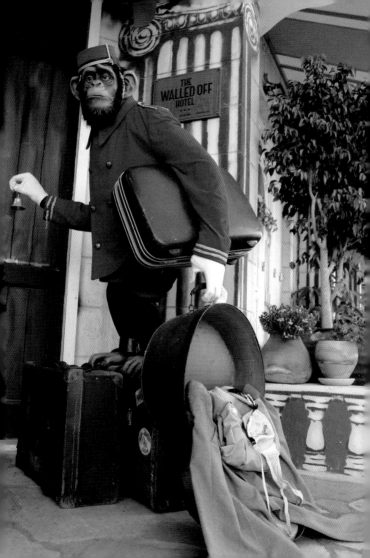

The Walled Off Hotel

In 2017 Banksy makes a surprise move by becoming a hotelier. The benefits were obvious though, a place to put artwork where it could be enjoyed free from taggers, thieves, or gallery invigilators. In a press release at the time Banksy was reported to have said, 'My accountant was worried some people will be too scared to travel to the West Bank, but then I reminded him – for my last show they spent a whole day in Weston-super-Mare'.

One visitor in an online review commented, 'the art looks professional' which will be a relief for anyone booking a room. There was also some Banksy memorabilia available on the website including a key fob in the style of a section of Israeli-Palestinian Wall, but at the time of writing the gift shop is out of stock (takes a casual look on eBay... ffs).

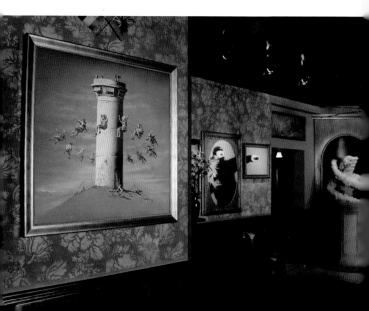

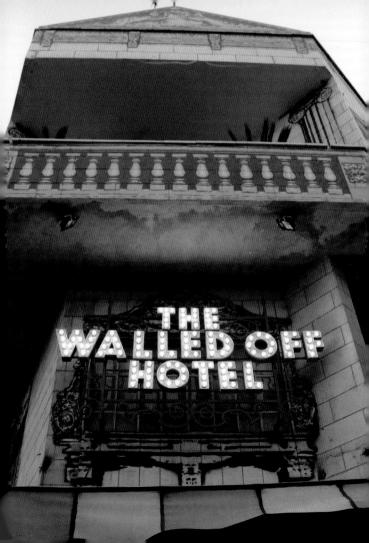

Brexit, Dover

The Brexit referendum vote took place in June, 2016 but it takes a while to sink in and for anyone to realise what leaving the EU might look like for the UK. Banksy's now classic EU flag piece was positioned to greet visitors as they arrive past the traditionally symbolic welcome of the white cliffs of Dover.

When it comes to 'Brexit Day' in 2019 the work is covered in scaffolding and whitewashed. The artist posts a snap of the piece painted over, captioned:

'Oh. I had planned that on the day of Brexit I was going to change the piece in Dover to this. . . But seems they've painted over it. Nevermind. I guess a big white flag says it just as well.'

Dover soles

Banksy's 'Brexit flag', (see page 32) becomes highly symbolic of the times and is used in many news articles to illustrate the tensions of Brexit. In 2019 it is whitewashed much to the dismay of many locals and even the local MP who calls it an act of 'cultural vandalism'. Nobody ever claims responsibility for the white wash. But one theory is that this was a revenge attack dating from when Banksy was last in the area and had painted someone's property without permission.

Mediterranean Sea View

Banksy has done much to increase awareness of the plight of migrants dying at sea, and the UK governments' poor responses to this issue that has resulted in many unnecessary deaths, including three-year-old Alan Kurdi who was a Syrian boy of Kurdish background. He drowned in September 2015 and the image of his body on the beach shocked the world. This Banksy triptych recalls those shocking events and confronts the viewer to remember him and the other 3,770 who died crossing the Mediterranean in 2015. Or the 5,143 who died in 2016.

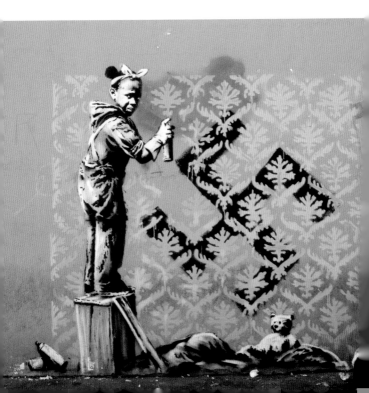

(2018)

The French Connection

A flurry of artworks in Paris, although mostly comments on the French response to the migrant crisis are also a reminder of the 50th anniversary of the 1968 student uprisings. It also spawned an art movement in Situationism said to influence the work of Banksy and other street artists. The works drop at the same time as Paris fashion week and this piece depicts a clever pattern concealing the fascist emblem of a Swastika.

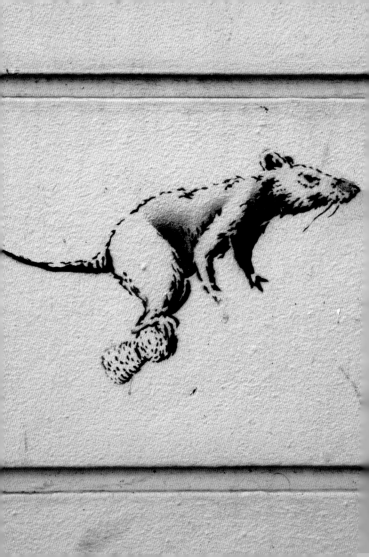

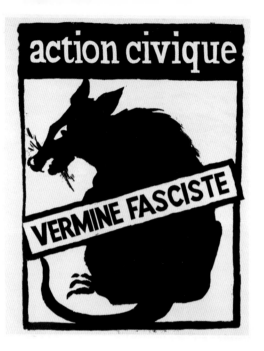

The year of the rat

A number of rats are also stencilled around town,
including one popping from a bottle of champagne.
The rat was an early moniker for Banksy, who was
often accused of stealing it from French artist
Blek Le Rat, but in actual fact, the rat was also
used before that in the 1968 student protests as
this image illustrates. Another slogan of the
protests was 'kill the copper inside your head'.

Raise the drawbridge

Hull, city of culture... no seriously, in 2018 Hull in East Yorkshire was the UK City Of Culture. On a disused bridge, Banksy pops up a little comment on Brexit. The next day it is whitewashed, but leading the charge for freedom of speech comes Jason Fanthorpe, a local window cleaner who clears off the paint with a bit of white spirit. The piece was later saved in its entirety by the local council who aim to have the piece fully restored by experts before putting it back on display. Apparently Jason is still on standby with his squidgy and his chamois.

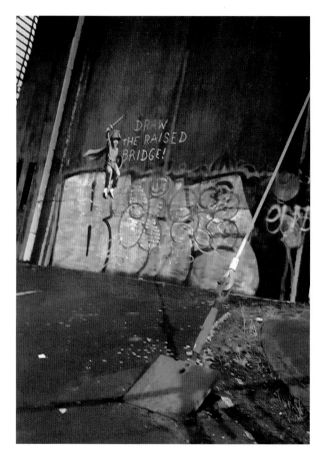

Balloon Girl Shredding, Sotherby's

What seemed like another day at the office for most followers of Banksy – a Balloon Girl piece being flogged off to people who buy investments rather than art at Sotheby's – turns out to be a 'masterstroke', 'an inside job', 'smoke and mirrors' and 'a rebuke at empty consumerism'.

The rumour mill goes into overdrive about whether the piece was meant to get stuck half way or not. Initially people think the buyer, who parts with £1.04m had been conned. But as is often the way, the headlines and general notoriety of the piece increase the value of the work which kick starts a new level of inflation in all Banksy valuations. In 2021, it comes up for a 're-sale', again at Sotheby's. The valuation? £4m to £6m, the sale price? £18.5m, and the piece is retitled 'Love is in the Bin' by Banksy.

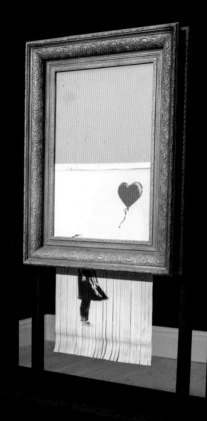

Banksy
Love is in the Bin, 2018

Sotheby's EST. 1744

Season's Greetings

Port Talbot is a steel-making town in South Wales, at night it looks like Gotham City but by day it boasts some of the worst air pollution in the UK. The young boy in the piece is depicted innocently ingesting this pollution during the first festive flurries of snow. Despite being the birthplace of Anthony Hopkins and Michael Sheen, the town wasn't expecting the drama that a Banksy piece brings. The town council hope the artwork is a springboard for tourists and regeneration, Sheen even dips into his own pocket to provide 24-hour security for the work. Despite everyone's best efforts the owner of the garage where the work sits sells the piece, and like an episode of Gavin and Stacey this Welsh wonder is shipped off to Essex.

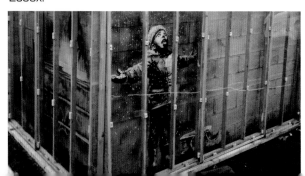

Permanent Banksy

Not standing for the temporary nature of street art is Ricky of Swansea who is inspired enough by the piece to go and get it tattooed across his chest. This masterpiece is guaranteed to stay in South Wales for longer than the original, which is finally removed in 2022.

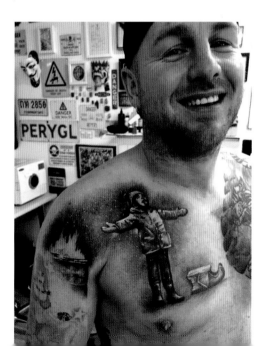

Summer Stormzy

Stormzy headlining Glastonbury in 2019 is regarded as a special moment in musical history as he is the first black male to top the bill. Oh, but what is he going to wear for this seminal cultural moment? A short video released by Banksy shows Stormzy being fitted for the Union Jack stab vest which Banksy suggested was 'capable of stopping bullets up to .45 calibre and is fully stab proof, yet not machine washable'.

The official line is that Stormzy had no idea until just before going on stage, and was also unaware until after the show that it was made by Banksy. Later that year it is in the Design Museum for Design Of The Year alongside Cold War Steve.

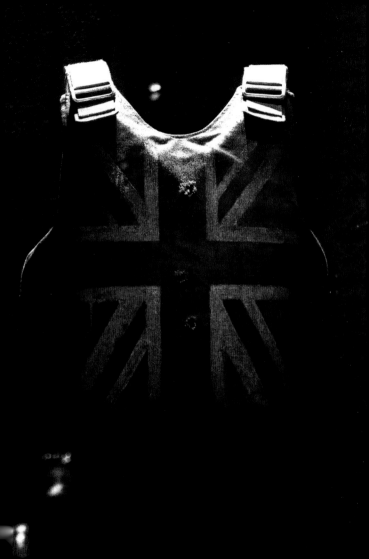

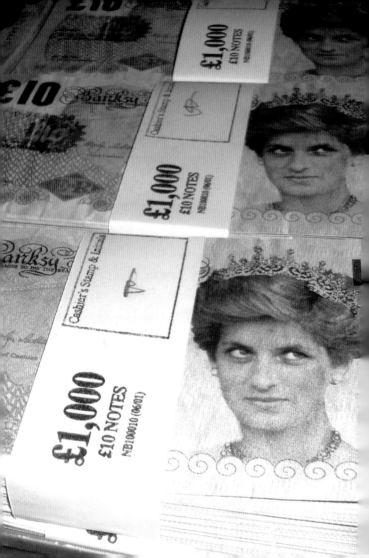

(2019)

Looking for a genuine fake

The British Museum announces in February 2019 that it has added its first piece by Banksy to its collection, and the piece is a counterfeit note. A Di-Faced Tenner was added to the coins, medals, and other currency section. Tom Hockenhull, a curator of modern money at the museum, said he had been trying to get hold of a genuine Banksy made Di-faced Tenner for years. 'The problem is, because [Banksy] was effectively producing them as photocopies, anyone else could do that as well, so there was no way to really verify whether they were from Banksy or not. There is a long history of political and social discourse through this type of protest which made us keen to acquire it' Hockenhull added.

'Venice in Oil' Venice Biennale

A one-minute film by Banksy shows a market trader laying out his stock – a jigsaw of paintings depicting a giant cruise ship dwarfing a traditional Venice scene. The trader is quickly moved on for not having the correct license. Speculation is rife on whether the piece is sold, broken up or binned. In 2021, the Venetian authorities finally restrict cruise ships from entering the Grand Canal. The image of a child refugee holding a distress flare was painted in Venice's Dorsoduro district.

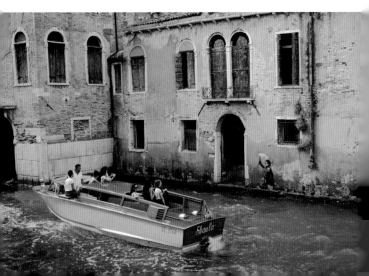

Gross Domestic Product, Croydon

Croydon in South London, aka The Cronx, saw the first official Banksy shop. Except it wasn't a real shop, and the few things it had to sell were sold very quickly. What was it then? Well, apparently there is an issue with people producing unauthorised Banksy merchandise. Not that we would know anything about such a thing, but apparently Banksy was unable to copyright some of his most famous images being used by one particularly persistent greeting cards company as he didn't produce commercial products. The shop was opened to disprove that claim, but the judge wouldn't budge and Banksy lost the case.

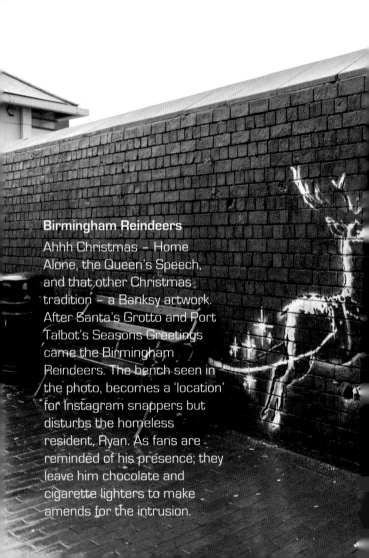

Birmingham Reindeers

Ahhh Christmas – Home Alone, the Queen's Speech, and that other Christmas tradition – a Banksy artwork. After Santa's Grotto and Port Talbot's Seasons Greetings came the Birmingham Reindeers. The bench seen in the photo, becomes a 'location' for Instagram snappers but disturbs the homeless resident, Ryan. As fans are reminded of his presence; they leave him chocolate and cigarette lighters to make amends for the intrusion.

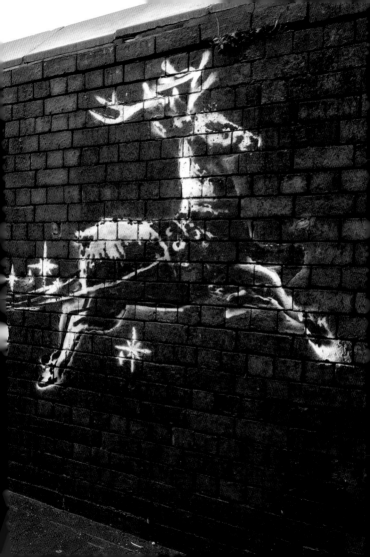

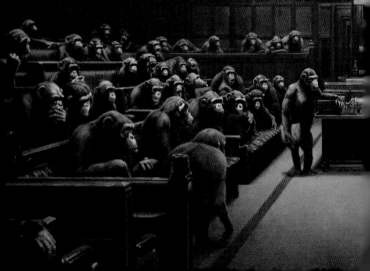

Led by monkeys

Whilst the Brexit circus was playing out in the UK, Banksy's 'Devolved Parliament' piece was rehung in the Bristol Museum for a short while. In October, the piece leaves for Sotheby's where is fetches the highest ever amount for a Banksy (at that time) of £9,879,500. 'Regardless of where you sit in the Brexit debate, there's no doubt that this work is more pertinent now than it has ever been' say Sothebys.

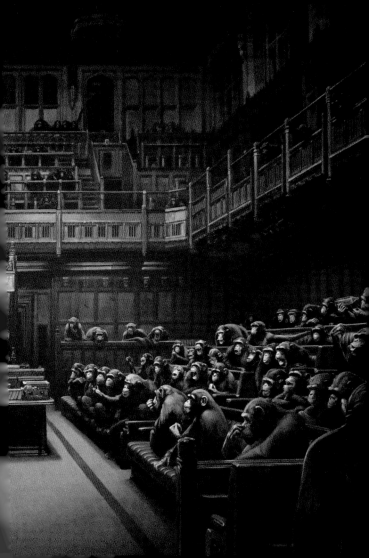

(2020)

Cupid Council

Spreading some love in the weeks before the first lockdown 'Cupid' takes aim at a random bit of overgrown topiary. The piece brings some Valentines romance to an often-overlooked part of Bristol. The same part of town where Banksy learned some of his trade at the Barton Hill Youth Club, later suggesting he feared the area because his dad was once mugged for his trousers there.

The artwork is dubbed with 'BCC wankers' one day after appearing presumably referring to Bristol City Council. On Insta Banksy himself says that he is glad that the piece got vandalised and posts images of the initial sketches creating speculation that he initiated the tagging.

Banksyfication

At Spike Island in Bristol 'The Girl With the Pierced Eardrum' is updated and instead becomes 'The Girl with the Mask' . At the end of lockdown, April 2021, the mask is taken off. Who puts it up and takes it down again is unknown. When this piece went up in 2014 there was a van opposite selling 'Banksy bacon butty's', in 2021 there is a new van which is a converted horsebox selling organic coffee and croissants.

Lockdown

The lockdowns of 2020 and 2021 provide plenty of inspiration for Banksy, with sneezing rats on the Underground. Followed by an Instagram image of rats seemingly running amok in what appears to be Banksy's bathroom, with the caption 'My wife hates it when I work from home'.

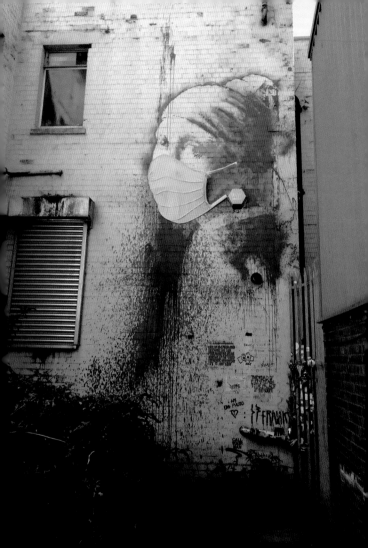

A giant artist

'The Girl with the pierced eardrum' provided more lockdown inspiration, this time for Bristol based artist @raygunsandrobots. Despite looking like a giant in the photo, he is actually of regular proportions and made a series of miniature street scenes with included iconic Bristol graffiti. They looked more realistic than the real thing and were much harder to deface.

When the Saints go marching in

In 2020, Banksy donates an illustration to a Southampton hospital depicting a child playing with their new 'NHS super hero'. The Game Changer artwork is eventually auctioned by the NHS trust, and was expected to fetch two to three million pounds for charitable causes. Two days after being put up for patients to view - like a scene from a horror movie - a man is caught by security standing next to the piece with a drill in his hand. When it does sell the following year, it sells for nearly £17m at Christies.

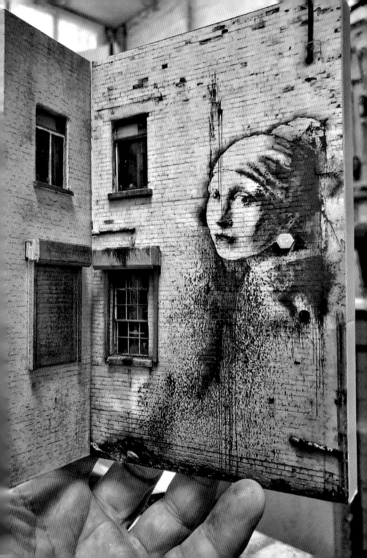

Captain badass

In Banksy Myths and Legends Vol 1 we showed how many Banksy pieces required boats, a theme which remerges in 2021s Spraycation piece 'We are all in the Same Boat.'. In 2020 The Guardian runs a story of how Banksy is funding a migrant rescue boat running between North Africa and Europe. The boat has a Banksy piece on the side depicting a girl in a life jacket reaching for a heart shaped rubber ring, in the style of The Girl with the

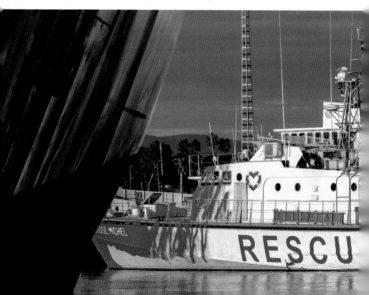

Balloon. The boat is captained by Pia Klemp, who has rescued thousands of people facing perilous journeys. Banksy sent a message with the donation:

'Hello Pia, I've read about your story in the papers. You sound like a badass,' he wrote. 'I am an artist from the UK and I've made some work about the migrant crisis, obviously I can't keep the money. Could you use it to buy a new boat or something? Please let me know. Well done. Banksy.'

Burn baby burn

If you thought any of the previous stories were far-fetched, imagine a world where someone takes a real life Banksy print and then makes a digital copy. They then burn the original and sell the rights to the digital copy to the highest bidder. This is the world of NFT (non fungible tokens). Oh, you want to know how much? Just £274,000 for this one but they seem to be multiplying and there seem to be people with the money to buy them.

Nowhere man

In Banksy Myths and Legends Vol 2, we reported how Mobile Lovers ended up on BBC's Antiques Roadshow and was valued at £40,000. Maybe drawing inspiration from this another punter arrives on the show carrying a bit of old masonry with an early 'Banksy rat'.

The owner recalls how he pulled it from a wall in Brighton in early 2000s but had failed to achieve authentication for the piece. Presenter Rupert Mass puts the broken hearted chancer in his place 'I think the message is, if you do see a piece of graffiti art out there, leave it for the public. I'm not lecturing you, I'm just saying, but without that certificate, it's just very difficult to sell. With it, it might be worth £20,000. Without it, you're nowhere.'

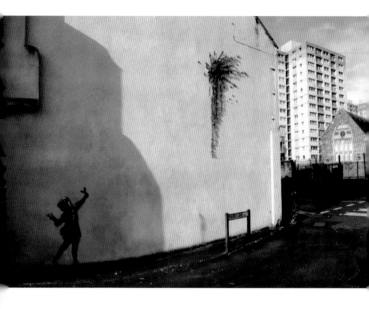

Cupid is dead

Another story around the piece suggests that the
work harks back to the classic 'Girl With Balloon'
and the girl is now bursting the balloon.

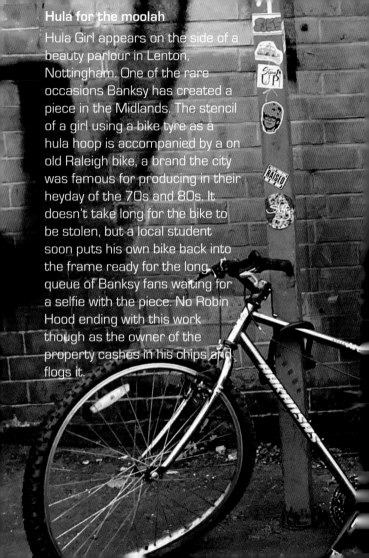

Hula for the moolah

Hula Girl appears on the side of a beauty parlour in Lenton, Nottingham. One of the rare occasions Banksy has created a piece in the Midlands. The stencil of a girl using a bike tyre as a hula hoop is accompanied by a on old Raleigh bike, a brand the city was famous for producing in their heyday of the 70s and 80s. It doesn't take long for the bike to be stolen, but a local student soon puts his own bike back into the frame ready for the long queue of Banksy fans waiting for a selfie with the piece. No Robin Hood ending with this work though as the owner of the property cashes in his chips and flogs it.

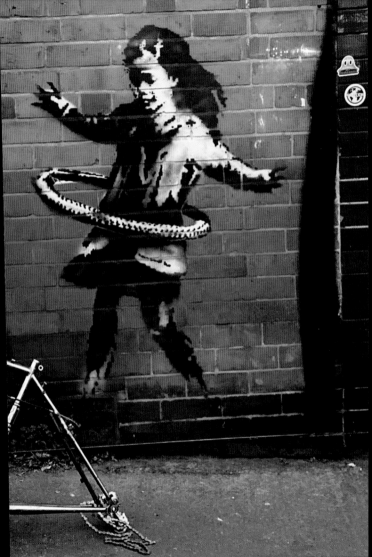

Massive Art Attack

In a weird side note to a an already weird year, children's TV presenter Neil Bucchanon of Art Attack fame has to issue a statement confirming that he is not Banksy. Hundreds of people on Twitter insists he is, in what is really just an example of what happens when you let millions of people work from home.

Art bot

An AI bot is programmed to produce a Banksy piece, it looks pretty shit. Stupid robot right? Right now a bot is being programmed to take over your stupid job, so laugh now but one day they will be in charge. The bots are called GAN (generative adversarial network), so of course this becomes GANsky. See what they did there?

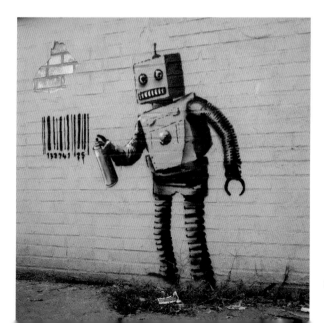

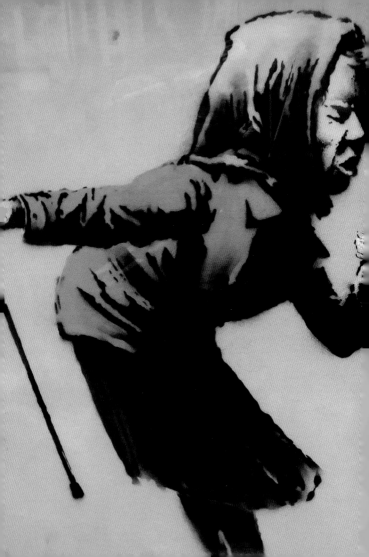

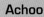

Achoo

England's steepest street is the location for Banksy's next covert Covid operation in Totterdown, Bristol. Some locals suggest that the artist chose the location simply to watch the many media outlets struggle to get their outdoor broadcasting trucks up the 22 degree gradient.

When the piece appears, word soon spreads about a man being seen early in the morning doing the graffiti but this being Bristol nobody pays much attention to that kind of behaviour.

(2021)

'No mistakes, just happy little accidents'

'Create Escape at Reading Gaol' is another location first for Banksy. This one is a big one in terms of size, it is a clever one in terms of a location - it can't be chopped out, bagged up and sold to the highest bidder. Stories circulate that it is a tribute to Oscar Wilde, or is it just a muse on the art of using creativity for psychological escape during lockdown?

The joy of not being sold anything

For the Reading Gaol piece Banksy's Instagram has a remix of The Art of Painting's Bob Ross, the series from the 1980s was rediscovered by many in lockdown. But why else would Banksy be interested in Bob Ross? Despite making painting accessible to millions it never occurred to Bob Ross to sell any of his paintings. He died in 1995 and all his paintings have been held by his estate. Thus making him one of the most famous artists to have never sold a painting.

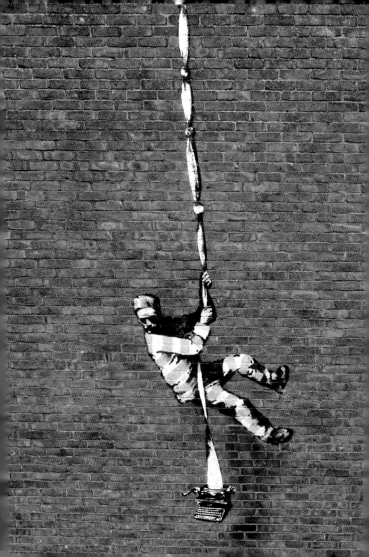

The 'Great British Spraycation'

The summer of 2021 is a bit dull in the UK. Foreign holidays are difficult and costly, everyone is piling into Cornwall creating new spikes in Covid rates. And the weather is also a bit dull. Sounds like a typical UK summer, but Banksy's next project brings some small joy to the seaside resorts of Suffolk and Norfolk. These new locations for Banksy cause unusual levels of panic and delayed reactions from local councils unprepared for the wave of fun that Banksy brings to town. Of the ten pieces, a couple survive, most don't.

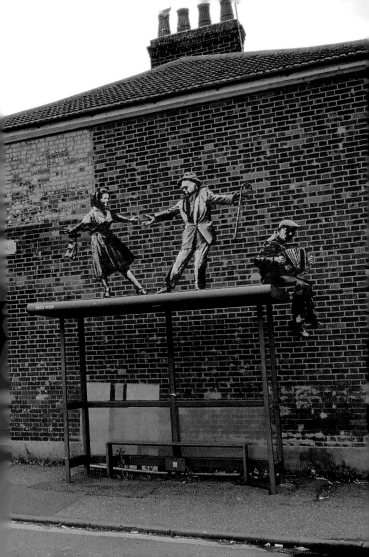

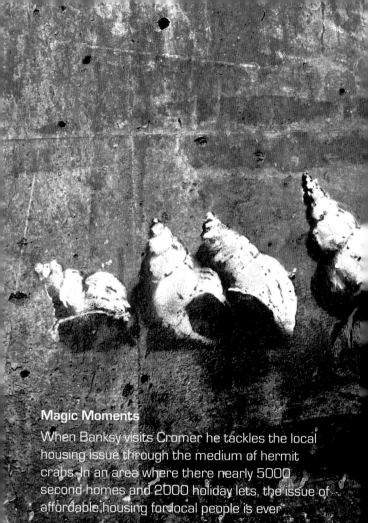

Magic Moments

When Banksy visits Cromer he tackles the local housing issue through the medium of hermit crabs. In an area where there nearly 5000 second homes and 2000 holiday lets, the issue of affordable housing for local people is ever

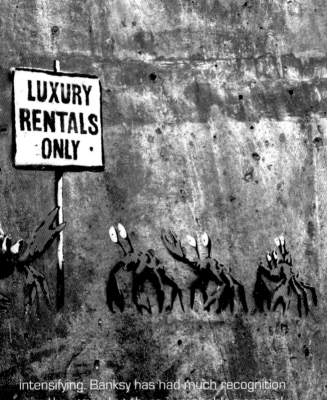

intensifying. Banksy has had much recognition over the years, but there is probably a special place on his mantlepiece for the 'Moment of the Year' award he received for this work from the North Norfolk News, even beating the local fireworks display.

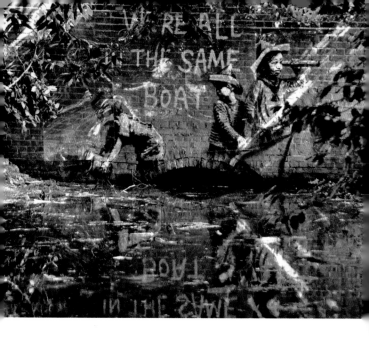

We are all in the same boat

Returning to the migrant crisis theme, this work uses what is now referred to by the UK government as a 'small boat' to highlight the issue in particular relation to small children who are pictured looking to the distance, perhaps for help. Originally the artwork used a piece of found corrugated iron that had been dumped in the river, but the local council claim it is a flooding hazard, and remove it for safe keeping.

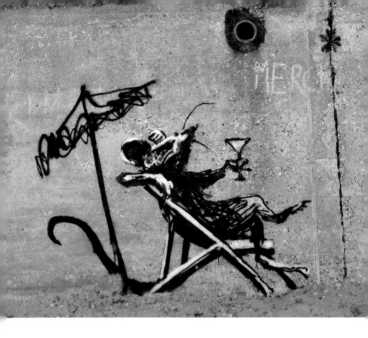

Steaming in

In King's Lynn a statue of former mayor and steam engineer Frederick Savage has been standing largely unnoticed for over 100 years. Banksy adds a tongue and an ice cream to the sculpture which draws large crowds, so the Council immediately remove it on the grounds of health and safety and the need for 'thoroughfare'.

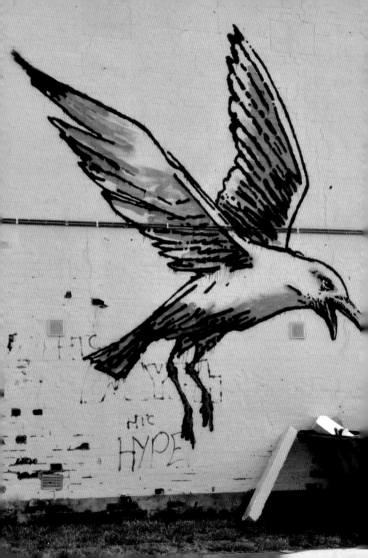

Modern art is rubbish

One of the most striking images of Banksy's Great British Spraycation tour is the seagull scavenging for food from a skip, which resembles a classic British chip tray. After a few days, the local council remove the skip, not to be killjoy's but because the public use it as an actual bin and fill it with so much detritus that it quickly becomes a fire hazard. The remaining image is preserved behind Perspex.

A matter of perspective

Staff at Merrivale Model Village in Great Yarmouth wake one morning to find that one of Banksy's smallest ever pieces had appeared overnight, a model stable with 'Go big or go home' sprayed on the side. A video accompanying Banksy's seaside tour shows what could be Banksy touring the region in a battered campervan. One elderly commentator is recorded as saying that his work looks better from far away rather than up close. Another suggests 'That looks like mindless vandalism, that'.

Hot tub time machine

When the Kids' Sandcastle piece is cut out from a wall in Lowestoft and sold to a dealer for a reported £2 million, local graphic designer Joe Thompson feels the pain more than most and is compelled to replace the piece on the side of his own house on the High Street. Recognising that a simple reproduction wouldn't be enough, he adds his own twist producing 'the Banksy vending machine'.

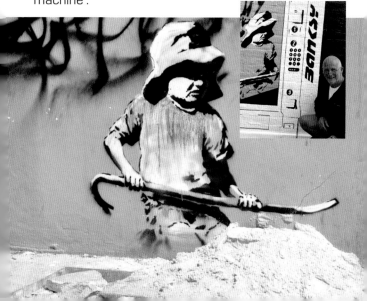

The nutty professor

Banksy has received several honorary degrees, the latest being from the University of the Creative Arts in London recognising how the artist 'challenges us all to confront some of the key issues of our time'. In the degree awarding ceremony, which surprisingly Banksy didn't attend, they left Banksy's certificate on a chair. A student from Bristol, Ben Wray took it upon himself to liberate the certificate and hold it aloft to huge cheers from his fellow students. Before legging it from the stage and plastering the jape all over social media for us all to enjoy.

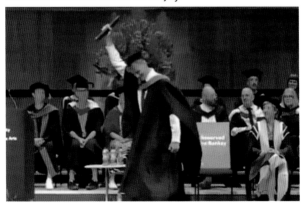

Lockdown legend

In 2021 during the second lockdown, whilst most of us were stuck at home baking banana bread and stuck in Zoom quizzes. Bristol based musician and parkour athlete Ilae Krivine aka Diebroke was hanging off a bridge naked for the sake of art. 'I needed something to do' he said 'I was going mad'. Parkour is a sport based on strength and risk and there were no ropes used in this photo. Check out @_diebroke if you don't believe me.

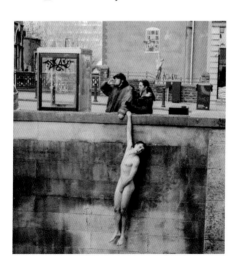

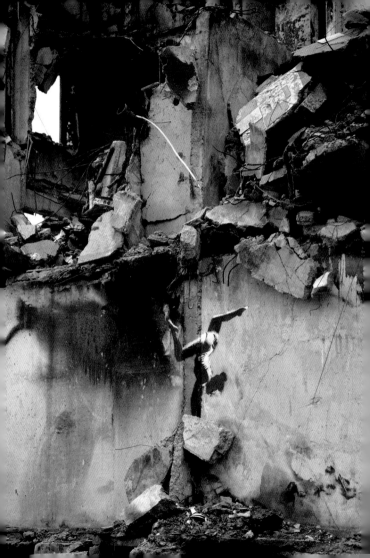

(2022)

Ukraine

To cynical western eyes Banksy's work in Ukraine might appear like a publicity stunt, but Deputy Minister of Culture and Information Policy of Ukraine Kateryna Chuyeva describes how Banksy is known to every Ukrainian, and that their history and culture are also under attack. She suggests the seven pieces of work Banksy paints immediately become part of the cultural legacy of the country and will help in the eventual rebuilding of Ukraine.

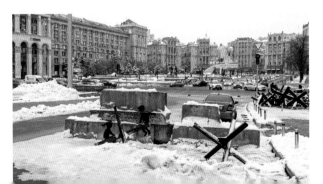

Mini massacre in Margate

On Valentines Day in 2023 Banksy leaves a memorial to the dangers of domestic violence by creating an installation in Margate entitled 'Valentine's Day Mascara'. Featuring a black-eyed housewife resplendent in marigold gloves disposing of her other half by way of cramming him into a chest freezer. Subsequent press coverage shows the freezer being removed (to local uproar), made safe and eventually put back again (to local bewilderment and hilarity). Whilst this side show takes place, local resident Tom Pettman springs into action and brings his pride and joy, a 1968 mini nicknamed Giles, to take centre stage.

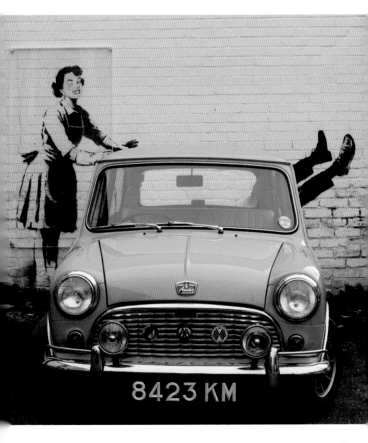

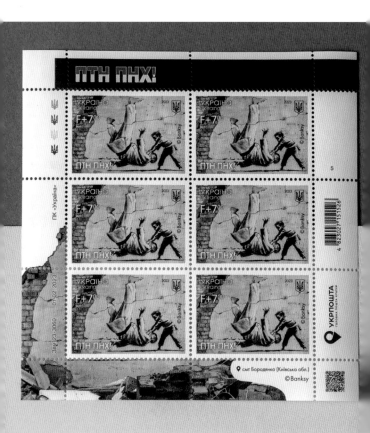

First Class

After Banksy's visit to Ukraine in the winter of 2022 Banksy leaves behind seven pieces, the most provocative of which shows a small child slamming a grown man to the ground. The Ukrainian postal service Ukrposhta issued the stamp to mark the first year of the Russian invasion in February 2023. The original piece in the town of Borodianka, north-west of Kyiv was on a wall partially destroyed by Russian artillery. Judo is reported to be the favourite sport of the Russian President Vladimir Putin.

Fck Putin

Whilst the Putin Karate piece is being created on the street local mum Yula Patoku and her daughter stop and chat to the artist, the daughter says how she appreciates the child winning the battle. It is only when the photos are published later that they realise it was Banksy that they had been chatting with.

THANKS

Thanks to the following for supplying images:

P2 Walled Off Hotel, G. Shove / P6 Walled Off Hotel, G. Shove / P8 Dismaland, Ashley Buttle Creative Commons / P15 Dismaland, Marc Leverton/ P16 Dismaland, Marc Leverton / P17 Dismaland, Marc Leverton / P18 Farhath, Barry Cawston / P19 Dismaland, Marc Leverton / P20 Rainbow, Barry Cawston / P22 Dismaland, Marc Leverton / P24 Steve Jobs, Calais, Rick Findler, Shutterstock / P27 Bristol, Marc Leverton / P28 Walled Off Hotel, G. Shove / P29 Walled Off Hotel, G. Shove /P30 Walled Off Hotel, G. Shove / P32 Brexit, Dover, Ian Clark /P34 Los Angeles, USA, Lord Jim /P35 Walled Off Hotel, G. Shove / P36 Paris, France, Olivier Suon / P37 Paris, France, Olivier Suon / P41 Hull, England, Julia, Creative Commons / P43 Love is in the Bin, Sotheby's, London, Ana Cross, Shutterstock / P44 Port Talbot, Wales, Marc Leverton / P45 Ricky by Swansea Tattoo Lab, Mike Thomas / P47 Gross Domestic Product, Croydon, Robert Flack / P48 Bristol, England, RJ Creative Commons / P49 Venice, Italy, Jarrod Zinjiro Creative Commons / P50 Gross Domestic Product, Croydon / P51 Birmingham, England, Brian Garwood / P54 Devolved Parliament, Sotheby's Auction, London Neil Hall, EPA-EFE, Shutterstock / P57 Bristol, England, Martin Booth / P59 Bristol, England, Marc Leverton / P61 Girl with the Alarm Earring Model, @raygunsandrobots / P62 Migrant Rescue Boat, Mediterranean, Wirestock Creators,

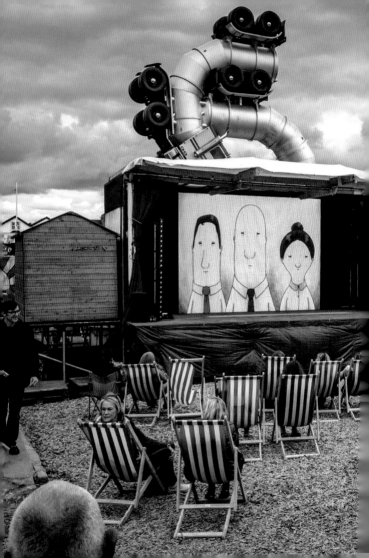